Summoning Pearl

David Zwirner Books

ekphrasis

Summoning Pearl Harbor
Alexander Nemerov

Contents

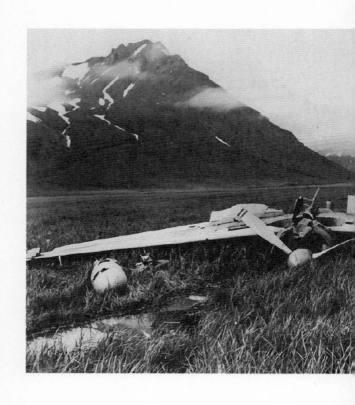

Reveries of Akutan

Now he had time to think. Tadayoshi Koga, nineteen years old, had just crash-landed his Mitsubishi Zero airplane on the remote Aleutian island of Akutan. It was June 1942, six months after Pearl Harbor, and Koga's plane had been hit as he attacked an American installation on the Aleutians. Leaking oil, his Zero would never make it back to the carrier *Ryūjō*, so he looked for a good place to land. His one error had been to mistake a flatland for a field, when in fact it was a marsh. Lowered for landing, the plane's wheels dug into the swamp, flipping the Zero upside down and breaking Koga's neck, killing him instantly. Five weeks later, an American salvage team would find the Zero and bury Koga nearby. But for those five weeks in summer 1942, all by himself, Koga had time to think.

It was a lonely study, but quietude of this kind comes rarely, and the unusual position—upside down in the cockpit—afforded a different way of seeing the world. The fog of Akutan curled around his knees and dipped over his stirruped feet. The elements seemed to recognize the airplane, to seek it out. Painted light gray, the Zero had blended with the prevailing Aleutian atmosphere, but now its camouflage took on a new purpose. The clouds came to it in kinship, as if the mist and rain recognized the airplane, sensed it, and—with no one watching—circled it with gray paws.

What did Koga feel in the thrall of that fog? Who is to say what the moisture felt like on his face, his broken neck. Who could say what it was like for him to experience the dew and rain of some thirty-five days and nights,

to let the perspiration drip from his chin to his forehead instead of how it had been in life: the other way around. Maybe there were several hard rains in those weeks, pelting rains, with some hail, so that echoing in Koga's ears, as he reflected, would have been the pinging and cracking sound of the hard drops and little balls of ice ricocheting off the airplane's aluminum skin. Wreathed in cloud, he became an unsung god, dipped in gray.

If Koga's head had been underwater (because it could have been, these matters have to be thought of), who is to say that this position would have been a bad one for thought? There was much to see down there, even if it was murky. The weird sensation of barely being able to visualize his boots, obscured by the film of dark water and maybe by flying goggles, gave him a curious feeling of walking on the sky. The stars at night, which he imagined as tiny gray-white puffs, felt like pulsations of tiny fish stroking Koga's face. The control panel, an aqueous mirage of dials and switches, faced him like a dictionary, but what had it all been about?

The sounds in the cockpit spoke to him as a transmission he had never heard before. The water made a gentle sloshing noise, accompanied by a slight creaking as the damaged airplane shifted slightly in the wind and boggy surge. Odd how these reverberations existed just on the other side of propaganda—how they were a speech before speech, words that had not yet become words, that had not formed themselves into directives and communiqués. Instead, they were saliva moving in the mouth of the world.

Koga might have loved the patriotic story broadcast on Japanese radio during the war, described by Ruth Benedict in *The Chrysanthemum and the Sword*, published in 1946, of an air force captain who landed his airplane after a perilous mission, scanned the skies with his binoculars until all of his squadron had returned, then reported to his superior with a full account of the day's action—only to drop dead, victim of a mortal bullet wound that had killed him when he had still been in the air. But Koga's death on Akutan was a dream not easily translatable to slogans.

Back when he was growing up in a small village in Fukuoka Prefecture on Kyūshū Island, Koga had a special feeling for submerged places. A tunnel in the village built some three hundred years earlier to irrigate the rice fields used to fill with water. "To boys of the village," Koga's cousin recalled, "it was a challenge to dive into and pass through the tunnel, and those who passed through were recognized as 'respectable heroes.'" Koga accomplished this feat two years earlier than most boys. Maybe Koga was thinking about that tunnel as he sat in his new state on Akutan, reflecting that now he was not so much traveling through a great long sluice as experiencing that sluice rolled into a ball, the exploits of his boyhood having become a dilemma befitting a Houdini, namely, how to escape from his own death, or rather—for this would be the ultimate trick—how to stay dead such that he found another way of living.

And so Koga sat, swathed in the furls of his flight suit.

Grass entered his mouth. "Large plumose, nodding panicle and large spikelets," wrote the Swedish botanist Eric Hultén in 1937 of a type of reedy grass, *Poa turneri*, first spotted on Akutan three years earlier. "Long ligulae and a long creeping rhizome," Hultén noted of the grass, describing also its "glumes and lemmas," long and narrow, and how the lemma is "in the lover part strongly villous." The shaggy grass brushing Koga's face was another kind of speech, sprouting deep within the mouth of a person whose language I do not know, and that Koga himself knew no longer. The virtue of speaking in tongues—the only praise for a gibberish of grass—is that it struggles to voice what is not known, that it tries to visualize the wet flow of things that fall permanently to the wayside of the familiar and the proven.

When American servicemen found Koga's Zero in early July 1942, they cut him down from the cockpit and buried him. His Zero, shipped to San Diego for restoration, soon flew again—the secrets of the new Japanese wonder airplane were quickly learned and demystified. As his airplane flew high above Southern California, climbing, dropping, sliding through the black-and-white air as the star of a short War Department film called *Recognition of the Japanese Zero Fighter*, Koga now really was dead. His new death was another kind of mist, not the gentle pawing seducing mist he had grown accustomed to over the previous five weeks, but an eradication, a fog of disappearance. He was gone.

The Dream World of Professor Ichihashi

At Stanford University, I am looking up at a sculpture of History personified. Behind the windows to one side of this sculpture was once the office of Yamato Ichihashi (1878–1963), a distinguished Japanese American history professor who taught at Stanford for many years before and after the war. In 1938, Ichihashi had spoken to a large audience at the university's Memorial Auditorium, defending Japanese aggression in China while insisting that Japan would never attack the United States. After Pearl Harbor, Ichihashi was crestfallen. Coming to class on Monday, December 8, 1941, he nervously peeked in at the door, entering only when his Stanford students politely welcomed him with an ovation. The attack meant "the death of all his hopes and his life," and soon he resigned. Persuaded by the president of the university to reconsider, he accepted a leave with full salary for the remainder of the 1941–1942 school year, but soon Executive Order 9066 intervened, and Ichihashi and his wife Kei were deported to the internment camp at Tule Lake, California, on the California-Oregon border.

Imagine Ichihashi on those remote flatlands. The level ground of the internment camp had, until three decades earlier, been underwater for centuries. The wooden huts went up on the bed of the former lake, which had been drained in 1905 to make farmland. The lake went back some three million years, part of a vast inland sea. Even the elevated features of the surrounding terrain such as Castle Rock—an 800-foot bluff sacred to the internees—had emerged through that water,

climbing up as hot melted rock that exploded on contact with surface water, the millions of particles from the blast assembling into a steep-sided cone.

The internees found plenty of freshwater shells at the camp. The women internees paid boys to collect these shells, giving them candy in exchange. From the shells the women made brooches and pins in the shape of flowers, gluing them together and painting them pale yellow and turquoise so that each mollusk became a petal or foliate bud. Saccharine in the palette of the 1940s, the shell jewelry is candy-like, as if aspiring to resemble what it was traded for. History is elevated and noble, pious and pontificate, like the sculpture at Stanford. Or it is fallen, confectionary, prehistoric.

On November 24, 1939, for Ichihashi's History of Japan course, a student named Frank Bush turned in his paper "The Mongol Invasion of Japan." Sounding like Ichihashi himself, Bush opens with a question: "How did a small nation like Japan repel the Mongols, the largest and strongest nation of its time?" He immediately answers, crediting "the help of nature" and "the brave spirit of most of the Japanese soldiers." Amid the emulation, the student repeating the professor's words, Ichihashi's occasional marginal notations are like the actions of a person taking a pocket-handkerchief and polishing a smudge to make the likeness complete. Or the notations are like nicks in the smooth shine of echo and imitation, a startling intrusion of the real presence of the mirrored person, as if Ichihashi had cut himself shaving and

touched the glass with his fingers so that the blood merged with his reflected image and became a more real version of himself.

At Tule Lake, Ichihashi watched Abbott and Costello's 1941 film *In the Navy* one evening in a rec room in the barracks. The bright patch on the makeshift screen made a show of just how different the mass-produced fantasy was from the genuineness of the night. But then maybe it was exactly the opposite: the bright gray of the projection was the one fixed reality, the illusions of concerted messages, gags, and slogans having become the one sharp and telltale truth. The surrounding night, starting with the splintered plywood of the barrack walls and floor and spreading to the sandy loam and the tule reeds blowing drily in the cold, did not exist.

Watching in the dark, Ichihashi succumbed to the dream that the pinprick of light created around itself. The fantasy of one-liners, of story lines and spoofs, of canned laughs and shticks, was a careful orchestration designed to put people to sleep. So great were the soporifics that the messages would reach even those who did fall asleep. As for himself, Ichihashi let the jokes flow past his ears and watched The Andrews Sisters—Patty, Maxene, and LaVerne—perform the movie's song-and-dance numbers. The sisters, homely, full of teeth, wearing different faux-military outfits, suggested to him some world beyond their simple declarations of ideological belonging ("We're in the Navy"). Their simplicity reminded him somehow of perfectly transparent windows,

sheets of glass so miraculously clean that they appear not even to exist. Mindful of the Modoc War fought on the lava beds around Tule Lake in 1872–1873, Ichihashi thought of the Modoc chief Captain Jack, of allegories of civilization, of swarthy rifle-holding rebels and white frippery in a combat of arms, of history writ in cleavage and spilled guts. He awoke to himself and thought of cloth stuffed into a split piece of wood.

Talking with a Kamikaze

Who descends out of the past? In 2014, I met a kamikaze pilot named George Tashiro, one of two former Zero pilots I had been told lived in San Francisco. Advised against speaking with the other pilot for reasons having to do with swords and alcohol, I called George and he agreed to drive down to Palo Alto to meet with me. Dapper, wearing a blue blazer with gold buttons, a white shirt, gray slacks, and gold wire-rimmed glasses, he arrived at my door.

George, who was eighty-seven at the time, carried with him a small leather-bound album with a leaping white gazelle pictured on a black inset on its blue cover. Sitting down in our living room, he opened the album, showing me photographs taken by a professional studio that depict his training at a school for kamikaze pilots in 1945. The album was to have been a gift for his mother after his death.

The photographs show young men, thin and strong, wearing white, hair shaved short. In some they do handstands. In others they balance on one foot, arms over their heads in a V, on a thin beam fifteen feet off the ground, or do cannonball dives into a pool. Turning the page, I see that they have crawled inside large balls made of bent wood and are pliantly using hands and feet to grasp the strut work of the globes so that they can roll themselves along the ground like human gyroscopes. Then I see seven cadets asleep side by side in their hammocks, dormant moths in white blankets atop white canvas sheets strung tautly across metal supports.

In another photograph, I peruse the faces of dignified people, dressed in kimonos, military uniforms, and civilian suits—a troupe of comedians and musicians brought in to entertain the cadets. And in one other picture—to me the most memorable one—several hundred young men in white shorts and shirts and caps all balance on one leg and extend their arms into flattened wings on either side, impersonating the aircraft they would fly to their deaths.

George was not sentimental about any of this. With a chuckle, he called the fabled Zero a tin can. With a wizened laugh, he referred to his youthful willingness to die for the emperor as a case of brainwashing. He was seventeen at the time. No hard feelings about it now. His escape—the war ended before he could fly his mission— provoked no meditation on having outlived his own death. Likewise the time he was almost killed anyway, when American fighter planes surprised his airfield and he narrowly escaped being machine-gunned as he fled into a stand of bamboo. This too was only a short and objective memory of war. He had lived a good life, busy and contented, and had been a very successful aeronautical engineer in the United States since the 1950s. George's photo album, although clearly a precious keepsake, was only a record of the past. Leaving it with me to peruse and return at my leisure, he said goodbye.

For myself, I was dissatisfied with this leveling of all times. I wanted the past in its otherness to emerge. I wanted it to be crude and powerful, an independent

force, like the sound of those old airplanes, of the Zero's 960-horsepower Nakajima radial engine, for instance. That sound was separate from poetry, from words, separate even from the airplane itself. In my imagination, the way the sound cut through the sky had a curious way of turning the heavens into a ribbon that seemed to emerge in tatters from this noise blasting across it. That sound, shredding the sky, asserted that it owed no allegiance to anyone or anything, not even to its native element of air. It was as if the airplane flew a bannered advertisement behind it that spelled out the onomatopoeia of its own roar.

Angels furled the scrolls; the heavens retracted; the trumpets swallowed their anthems. Every episode of war was a separate apocalypse. Who George was died with the mission he did not make.

Stephanie and the *Hornet*

I am on board the *USS Hornet* in Alameda, California, with my friend Stephanie, a woman in her forties who grew up in the Bay Area.

In 2012, Stephanie walked the route of California's El Camino Real, covering the eight hundred miles between the twenty-one Spanish missions from Sonoma to San Diego. Her aim, she told me, was "a protest against the human predicament." El Camino Real had been traveled for centuries by native peoples, then by eighteenth-century burros and friars and their slaves, and now by modern-day cars and trucks. Walking on this royal road past fields, past car dealerships, past fast food restaurants, and back out into brown meadows with no one else in sight, Stephanie felt ages surge around her. She felt connected to times and people beyond her, solid with them in all their substantiality, yet also as absent from the world as each of these invisible denizens of past and future time. The walk was her way of letting go, of creating the curious sensation of escaping herself and escaping time—of letting so many times come to her that none was foremost.

Now, Stephanie and I stand at the edge of the deck of the aircraft carrier *Hornet*, the sun glinting off San Francisco Bay, a light June wind rippling our hair. It was from this part of the flight deck on the *Hornet*'s eponymous predecessor that B-25 bombers had taken off to bomb Tokyo in April 1942, the first vengeance after Pearl Harbor. The new *Hornet*, built in 1943, is now a museum of military refuse, cluttered with swept-wing, pointed-

nose, insect-like airplanes of the Vietnam era. Aloof in their praying mantis forms, stenciled on the sides with pilot names such as Bucky and Buzz, these airplanes are hostile to our meditation. Elderly fez-wearing docents stand near them, ready to recite stories of yore. Stephanie and I escape, going below decks.

Down there, in the labyrinth of narrow passages and steep metal ladders leading to bunk rooms and galleys, we inhale the peculiar military smell—a mixture of paint, cordite, and antiqued male funk. We note the impersonality of walls, mess tables, and bunks, sensing the strict anonymity of the decor and its proposition to the serviceman: you will not recognize yourself. There is nothing here that concerns *you*. Let the evidence of yourself diminish in the discovery of this world without reflection.

We find the throbbing heart of the now-quiet engine, sleeping in its room of meters and levers. Stooping into doorways, turning corners, and staring through screens of metal mesh, we walk among the gray passages and think of the mind of the ship, of minds in general—of passageways and walkways out of Hitchcock and Dalí, dream sequences Hollywood-style, of traumas and evasions and dead-ends and spiraling staircases that recall who we are and where we have gone and how we have gotten lost. Stephanie does not mind me writing of her depression, of her traumas and sadness and her long-walking resolve, of her father muttering nonsense to himself in a North Beach café and of her own attempt to

portray, in the measured meter of her words, some note of sanctity and sanity.

Stephanie and I move through the hidden passages, observing histories that are and are not our own. But what we note most of all is the way the past retreats before us. The absent crew is at our service, beckoning backwards, not as a macabre array of saints and ghouls, flesh burned in perpetual harrowing, but gently, coaxingly, instructing us in the art of not taking hold, not of them or of anything.

The historian, we agree, measures the retraction of the world. With each step she takes, the past recedes a step further. Sensitive ghosts perpetually retreat, ever curious to explore their native atmosphere of disappearance. Yet in that duet, a fellow feeling emerges between the historian and what is not there. Around every turn, beyond each corner, we taste the communion of many times gathered and gone in the same place. The wafer of the galley, the reflection in the stainless steel: both emit an imaginary taste. Emerging back on deck, we find that every breeze, every glint of sunlight, and all the thick water slapping the gray hull play the same tune. It is a kind of craziness. On the one side meaninglessness; on the other the gorgeous swan song of historical awareness. Between, some dream, sliced in the waves.

Being an Idiot

Akira Kurosawa's 1951 movie *The Idiot*, based on Fyodor Dostoevsky's novel, tells of the epileptic Kameda, an impossibly kind and saintly mystic. An unworldly being, Kameda is the only one to see the soulful good in a dark and tormented woman, Taeko Nasu. She comes to love him, while her own lover, the bellicose and passionate Akama, turns to loathing her and resenting Kameda. The movie ends with Akama killing Taeko Nasu, and Kameda compassionately holding the killer.

In this tortured path Kameda moves within history. He and the warrior Akama huddle at the end like traumatized soldiers in a bunker. They "embrace defeat," as in the title of John Dower's book about Japan in the wake of World War II. But Kameda's idiocy also sets him free from history. Like the snow that falls constantly in the film, Kameda drifts softly beyond definition. The beardless face and soft voice of the actor Masayuki Mori, who plays Kameda, appear in scenes in the way that the snow falls—in drifts, in powdery rain—so that it is not the frames of the windows nor the panes of glass through which we see that snow but the cold air blowing from nowhere and everywhere that is his medium.

Taeko Nasu's crimes and crying, her heartrending guilt and repentance, amplified in the soundtrack, beat against the empty space that Kameda creates wherever he is. The snow itself is afflicted with his epilepsy, losing track of its whereabouts, blowing spasmodically in the sky. The gray of the Hokkaido winter and the gray of the film conspire to drown the world of allegories and plights

and real-world situations in this calmest of storms. A kind of zero.

Maybe the historian, embracing defeat, is also meant to drift through the world. Maybe only that drifting can secure him a place. Maybe only by being snow can he be certain of not freezing to death. Maybe only by identifying with the snow's way of making and obliterating his footsteps can he see that the point of history as ecstasy, as storm, is the creation and erasure of oneself.

The experience of being the snow is out of body— a seizure. What blows into the historian is not inspiration, not afflatus, but the gusting of a crack-cheeked wind, an impersonal force that chooses him for the brunt and the softness of its fury. This is the dream of the slow, of those bitten by the snow.

The Sleep of Iwao Peter Sano

When Iwao Peter Sano and his classmates graduated from the eighth grade in Southern California in 1937, they received free tickets to see Disney's new animated movie *Snow White and the Seven Dwarfs*. Iwao was part of a large Japanese American farming family living in Calipatria and neighboring towns near the Salton Sea. His mother, a devout Christian, did not want him to see the film and advised him to read Scripture instead. But he went to the movie with his friend Ao.

Two years later, Iwao was sent to Japan to become the son of a childless uncle and aunt. In summer 1941, as he and his schoolmates stared from the windows of their classroom at a grand flying demonstration of the Japanese air force, a classmate turned to him and said that the squadrons were proof that Japan could beat America in a war. Later that year, Iwao heard the news of Pearl Harbor on his neighbor's cranked-up radio, not in the form of an announcer's words but in the resounding tones of the Gunkan (Warship) March. Only a few months later, Iwao looked up to see, amazingly, American B-25 bombers skimming the treetops over Tokyo on the Doolittle Raid, a first sign that the Japanese home islands were not impervious to American attack. Conscripted at the end of the war, Iwao no sooner joined his unit than he was captured by the Soviets and sent to a prison camp in Siberia, where he remained until 1947.

It was only when he fell into the snow outside his barracks in the Russian winter that Iwao woke up. In the war he had been more willing than even the Japanese-born

soldiers to dive under an enemy tank holding a grenade. But now he came to, looking clear-eyed around him. The last time he was awake was maybe as far back as when he and his friend Ao had entered the movie theater in Brawley, California, to see *Snow White*. It was during the movie, somehow, that he had fallen asleep. "A magic wishing apple," says the witch. "One bite and all your dreams come true." Like Snow White, Iwao had some-how bitten into the apple. "I feel strange," the girl mur-murs, losing her balance and slumping to the floor as the bitten apple rolls next to her and the hag cackles.

Conscription, enlistment, custom—a bite of the de-licious fruit: "There must be something your little heart desires." For Iwao and Ao (who also moved to Japan soon afterwards), the sleep that began at the theater was the spell of mass-produced messages, of enticements like the Gunkan March and the witch's ugly allure. I want you, I need you. Such an inducement, such a seduction, the clutching of children.

The past is a slumber of many layers: unconscious, unthinking, dead. It can only dream of what it was. It is gone and even when it was not—when it was fresh-faced and as yet un-seduced by the hag and the fog—it did not know it was awake. Events cast a hex on life as it unfolds, dispensing drams and elixirs to each actor who plays a part. Every act of these actors is a drinking of their action. We recall what we did, we differentiate between our states of waking and sleeping, yet much of what we experience feels like the vapor of a dream. So it is that each player in

the past has left no mark. As the beverage went down the throat, so the drinker was erased by degrees. All that is left is the bottle that contained the potion, which, not being consumable itself, fell and cracked on the pavement. Finding the broken glass, the historian smells the perfume of this long-ago stupor. Not by degrees does the vapor of the past's vanishing come to him. Rather, he gets it all at once, close to the glass, and becomes intoxicated. Holding the broken bottle to his face, he notices that his fingers start to disappear and puts it down. But then he picks it up again.

Fear Itself

The Wolf Man, starring Lon Chaney, Jr., was playing in American movie theaters in the months after Pearl Harbor. Chaney's character, a simple, fun-loving American named Larry Talbot, innocently comes to England to work on his aristocratic father's estate. His only aims are to help his dad and to chase women in the nearby town. But when he is bitten by a werewolf, Larry finds that his feet turn to hairy paws and his teeth become fangs. Roaming the forest, slinking through the dry ice mists, he looks for prey even as some part of him, afraid of the hunter, fears the thing he has become.

"The only thing we have to fear is fear itself," Franklin Delano Roosevelt had proclaimed at his inauguration in 1933, in words that must have resonated in the days after Pearl Harbor. But when Larry awakes in his bed to find evidence of his nightly assaults, he is scared out of his mind. He does not want to be a killer, and he does not want to be killed.

He has no choice. Savagely clubbing the murderous wolf on one of its prowls, Sir John Talbot does not realize that he has killed his own son until his homicidal rage is spent. Only with time-lapse photography, which shows the hirsute layers peeling one by one back from the wolf's face, does Sir John see that it is his son lying dead.

The historian comes late upon the scene. Examining the plain rooms of the past, he studies the wooden walls, looking at the color of the wood, at the knots and whorls and grain. And in those patterns, impressed by slow centuries, planed at the mill, he comes to feel the originality

of the wood back when it was tree, the carvings and buf-fetings of it in the wind and snow, the tenacity of the roots in the dust.

The dendrochronology of pain, call it—the snarls trapped in the wood. Everywhere around him in the room is the fungal deposit of time, gathered and crusted and, over the years, polished into a false smoothness. Every empty chamber, every wooden cabin, enshrines these screams. When Sir John Talbot beats his animal son to death, the two of them, man and man-child, write their fates in the tree where the killing takes place. Fixa-tions in the bark, platitudes of desire, huge energies nailed into place, the four-square architecture of the tight and true still contains, everywhere you look, a gallery of fears, of superstitions and lore.

Looking through wooden drawers of censored war-time photographs showing dead American servicemen, I find that the mouth of a man in one picture curls back to reveal his teeth. His wavy hair, stringed with mud, is baking dry in the fly-flecked heat. Shriveled ribs of ooze make a washboard pattern around his half-submerged body. Clawing the ground, he looks like a swimmer un-able to complete his explosion from the water.

The soldier's fate, foretold by Hollywood, will unfold in the matinees of a thousand Saturdays. Portrayed by a werewolf, the doomed soldier will occasion the delighted shrieks of children and the interlocked fingers of teen-agers, their hair smelling of geraniums and their ears ringing with prohibitions and dares. As the wolf on-

screen, the man will howl to Jimmy Lachrymose and his date Dolores, lovers neck and neck, their faces silhouetted in light. Mutely, he will introduce Darryl Dalrymple to Lucinda Boohooley, glad for them to go together, watching the tears drop and the fluffy sweaters flutter.

Yet the soldier in the mud wonders why he will go down in history as the one whose scream was never heard, silenced except in the wolfish echoes that fall on deaf ears. How could it be that he will be only a dream of puberty?

The lovers look each other in the eyes. The boy will kiss her now. His mouth is open. Her mouth is open. The hairy man on the screen—his mouth is open too.

The Underpass

In Palo Alto, an underpass separates the town from Stanford. Built in 1940, the underpass was dedicated along with a new art deco train station in a public parade in March 1941, nine months before Pearl Harbor. Photographs of the parade show plenty of American flags, including those held by the Japanese citizens of Palo Alto, a group led by a bald man in white pants, white shoes, and white shirt. In another photograph, above the majorettes twirling their batons, a theater marquee advertises the movie *Flight Command*. Military preparedness is in the air, along with uneasy declarations of patriotism.

Walking through the underpass now, I consider the dark tunnel of 1940–1941. Scrawled with graffiti and smelling of urine, clammy with the cool air trapped along its cement walkways, the underpass suggests a crypt or church—some sacrosanct place, devoted to ritual. Down at one end, visible in the bright rectangle of daylight in the Stanford direction, a squat palm tree glows in the sun. Its fronds are like the claws of reptiles, or the fanned tails of macaws. But the shadow world of the tunnel is a headier illusion. It sleeps in pleasant dormancy, muted and dark, missing only the bugs and bats that, had they roosted there, would discover in this shallow space the secrets of their own hibernation. It is defiantly unadorned and unimaginative, a generic structure of a kind that civil engineers must have made in the hundreds, all across America, during the national infrastructure upgrades of the 1930s.

From this nothingness—compounded of triviality and ugliness—American writers spring their grace notes. Leave it to Borromini to make his naves fluctuate, his ceilings bend, and his cornices stutter and float in raptures of religious ecstasy. Leave it to Bernini to comport his angels into marble-winged episodes of lithesome beatitude, glory extending from toes to fingers and out in invisible cylinders beyond the touch. American fonts are sans serif. Their only scrolls are those that warn of trespassing and electrocution.

Does Pearl Harbor bang around in this echo chamber? Maybe the plaintive and forgotten things—the cracks in the tarmac, the spiderweb shatters in the glass—seek the shelter of ignored places. Traveling the tunnel, curator of the emptiness, I keep the past safe from being commemorated.

Of Thought and Lust

Many years ago, as an undergraduate at the University of Vermont, I liked to study art history in a small room on the fourth floor of Williams Hall, a beautiful redbrick gothic building erected in 1896 on the university's campus row. One book I especially recall reading in that small room, its walls painted white, is Svetlana Alpers's *Decoration of the Torre de la Parada*, a study of Peter Paul Rubens's oil sketches for the hunting lodge of King Philip IV of Spain. Those sketches fascinated me as I sat in that fourth-floor room. I would be there for whole stretches at a time, from, say, 7 to 10 p.m., reading attentively as Alpers described the art of Rubens and the *Metamorphoses* of Ovid on which it is based.

I read of Hippomenes chasing speedy Atalanta, tricking her with the ruse of dropping the golden apples. Of the couple unwisely consummating their post-race lust in a cave sacred to the gods, and of their transformation into lions as punishment. I read, too, of Apollo chasing Daphne, Pan chasing Syrinx. Nymphs changing into laurel trees; nymphs changing into river reeds. Jupiter and Io, Jupiter and Ganymede, Jupiter and Callisto—seductions, abductions, swelling tummies swirling past me in rivers of black-and-white illustrations, through which I could sense the carmine of Rubens's fluid brush, the melting muscles of his jackknife assassins and peeling maidens, their suggestive forms askew in beds and gardens and skies.

One myth I especially remember reading is the story of Tereus, Procne, and their son Itys. Tereus sleeps with

Philomela, his wife's sister, then cuts out her tongue to keep her quiet, only to have Philomela weave a tapestry detailing the crime. Seeing the tapestry, Procne kills Itys and serves him up in a pie to her unsuspecting husband. Rubens, up to the task, shows bare-chested Procne running in to the king, holding Itys's head like a live grenade in her two outstretched hands, rousing the king from his postprandial contentment to show him the substance of his feast. The stricken monarch flails his left arm in a spasm of disgust and claws at his sword with his right, meanwhile staring at his son's severed head. The clothes that Rubens's people wear shiver with passion, like carnal weather maps, so that maybe the master did not even need to include the pendulous breasts of the aggrieved Procne, Philomela storming tongueless behind her, to achieve the total effect of fleshy abandon: a banquet of sex with a great big disgusting sex pie.

Outside it was winter. The snow had fallen and it was white all across the campus green and the air was cold and clear. The old clunking radiators of Williams Hall were so hot that I had opened the window wide on the January night I most remember, and through the lifted sash and the transparent coolness, I could see clearly all the way to the lights on the other side of Lake Champlain, to the Adirondacks in New York State some six miles away, to distant, glimmering farms.

Occasionally looking up from Alpers's book, I became aware of an obscure kinship between my studies and the faraway places suggested by the twinkling lights. There

seemed to be benevolence in this kinship, as of a world in order, at peace. In the daytime—I also studied up there on beautiful fall days—I would look at a large red barn on the New York shore—it must have been huge to be so plainly visible that far away—that seemed to tell me (for some strange reason of my own) that goodness exists in the world. It was a barn with a gold-topped roof that spangled in the sun. Set off by a vast green field, it was part of a whole spectacle—gold, red, and green—that looked to me like some mystical emblem of charity, though I could not say why.

But at night, the far shore had, of course, a different aspect. The Adirondack Mountains loomed large, dark against the dark sky. Eroded through eons, they still rose forcefully in granite and iron. And as I studied in the small white room, reading of Tereus and Procne, of Apollo and Daphne, and the others, I felt those peaks echo in my solitary study. Imagining what was happening way up in those mountains as I wrote my notes, I would envision a fox pausing in the snow, twisting its body into a serpentine shape to eat a mouse, tilting its head to bring the back teeth into play.

In Williams Hall I was a mountain dweller, a hermit. I congratulated myself on the solitude of my lonely place. No one to disturb me, just the cool air on my face as I took note of elemental things. From their page-bound furies, Ovid's gods occasionally gave me an inquisitive glance, momentarily curious about the person observing their passions.

But at those times I also felt that my solitude left something out, something that intervened literally between me and my mountain reveries. It was the town of Burlington, Vermont, situated down below in a grid of streetlights and silhouetted roofs and snowplowed streets.

The drinking age in Vermont was eighteen, and Burlington featured a famous bar life, really an out-and-out celebration of alcohol and alcoholism (at bars such as Rasputin's, Finbar's, and The Last Chance), in which most students, including me, participated with varying degrees of abandon. For every student who fell from a fraternity roof in a drunken mishap to become impaled on a garden fence, there was another struck down by a freak accident of equal horror, or else simply injured or left unconscious in a bush, or against a tree, or partway across a roadside curb.

Then there were the less spectacular events of an ordinary weekend or weekday. These were just the plain, everyday hard drinking and socializing and coke snorting of the early 1980s, when doing lines took place in the open, as well as the rampant sex of that era, just before AIDS hit big time. All of this was going on down there in Burlington, and I had a small part in it, to be sure, to judge even now by my memories of the décolletage of debutantes and similar sights that come back to me.

I remember a time in the vast college library, late at night, when, reading a book, I was shocked to see another student, a young man, walk over to the girl studying quietly across the table from me and—without any to-do

(they obviously knew each other well)—reach down and stroke her long and lovingly between the legs. I still remember her purring smile as he did this. It was all so beyond my ken that to this day I do not quite believe I saw it. I envied the couple their familiarity. And I felt that it was somehow addressed to me—the boy's ease, the girl's pleasure.

Across the table, I made my notes. I studied for the exam. I did whatever I was doing. I drew away a deep love—for Rubens, for Ovid, for the book of art history by Svetlana Alpers and others like it. But there was an aridity to my studies, a caution, a repression. I read about mayhem.

Now, seeing the past quiver before me—seeing it erotically shake in grindings in the sand, kisses at the train station, and in all the failed and fumbling attempts that led to letters or no letters at all, only to a silence that outlasted time and came to be the definitive word on a subject that was as if it never was—I think of December 7, 1941, and doubt that I can ever portray it.

From Eternity to Here

When I finally went to Pearl Harbor for the first time, I noticed the most famous fact about being there. From the memorial directly above the submerged *uss Arizona* and the entombed remains of its crew, I observed that the ship is still leaking oil. Silvery-blue and orange tie-dye pools spread on the water's surface, floating all around the crusty turrets creaking in the air and the pale patterns of battleship steel shimmering a few feet under. Here was the past still emerging in the present, taking an aquatic form like breath spooling up from below, a psychedelic exhalation as though the state of being dead, and being dead right under a never-ending stream of tourists, required a streak of showmanship, a never-ending colorful wound, extending in a slow ectoplasmic leak, a kind of never-ending guitar solo, that would play out the souls of the chiseled dead in incremental liters until the end of time.

Maybe what went on down there below decks was a party that tourists like me on the beautiful white memorial might only begin to guess. The good cheer of my fellow visitors was being repaid in kind, with interest, by the raucous celebration taking place below. The dead's revenge on the living would be to refuse the gloom, to enliven the oceanography of the sunken metal corridors and common rooms with hats and streamers, all so that the pious rituals of commemoration—of never forgetting—would get their comeuppance.

In those oil smears on the water, the dead began to take shape for me as a group difficult to please. They were

rowdy, unruly, not only in their sailor patois gurgling up in halting, half-strangled offensive phrases. They were unruly in their unwillingness to be helped or honored or remembered. *Et in Arcadia ego* the tomb says to the shepherds, but it was the great *fuck you* of the past to the kindhearted present that I thought I heard in the oil.

I learned that Elvis Presley had staged a benefit concert for the Arizona Memorial on March 25, 1961, in Honolulu's Bloch Arena, raising $62,000 to ensure that the memorial, designed by architect Alfred Preis, would be finished and dedicated the following year. The King's songs that night—opening with "Heartbreak Hotel" and then "All Shook Up," and concluding with "Hound Dog"— must have roused the sleeping crew of December 7, 1941, enough to remind them of a world they never knew.

Something of those glossy tones glugging down beneath the waves, battering around the corridors like stray sonar or the pinging language of beluga whales, must have played loudly enough to hint to the stronger men on board, the leaders of the dead, that something new was afoot, from which they were all supposed to benefit. On that night, emanating from Elvis, the sounds rang down into the bunks of even the deadmost of the dead. Maybe the sailors misunderstood, but the songs seemed like a call to arms they might heed and use as the model, the template, for their own voices. It was a way for them to do away with their doom, to spread good cheer in the only way the dead men knew: by echoing the bubbling flow of the voice they heard from above. Funny how it

was that the past—to pay back the present for its senti-
mental attention—needed to draw on this same senti-
ment for its own lifeblood. The oil that had always leaked
now became their song.

I saw myself in a theater—back then, or was it now?
The black-and-white film of the aftermath of Pearl Harbor
was spooling out, showing the listing battleships and
smoky skies, but back in a corner of the theater I was
looking at the floor, examining the stains there, the
grounds of popcorn and the gum darkly blooming on
the great flowers of the carpet, the usherette's flashlight
beam bobbing on the steps.

A Zero flew on the screen, even as another appeared
in my inspection of the floor. Intrigued, I bent down to
see what the airplane was made of. I seemed to see in it
all things, like it was an encyclopedia of its time. I found
it was made of gum wrappers and lipstick and of the
darkness itself. I wondered if, over time, the days of Pearl
Harbor had gotten so mixed up that the past had become
one enormous headcheese, a great kaleidoscopic pâté,
things great and small now mosaicked together. Senile,
these long-ago things had forgotten their proper func-
tions, and now were helping each other as best they could
to resemble their just duties and purposes, to approx-
imate their official heraldry of appearance, just on the
off chance that someone like me might come along and,
peeping in, hope to find everything in order.

But they could not remember what they had been
about. So it was that the airplane's wings were made of

a young woman's sneakers and the sneakers were made of the wings. So it was that if you pressed your finger against the metal fuselage you would find that it gave like a belly, or the fleshy part of an arm; whereas if you could somehow reach out to touch a woman's body from that time, or a man's, you would find it curiously hard, metallic, like it was riveted together.

So it was that the soul of things evaded me.

Photographs from George Tashiro's Album

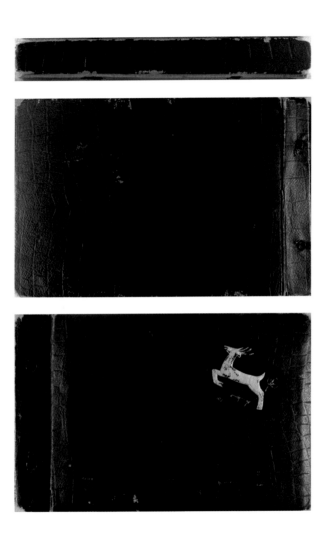

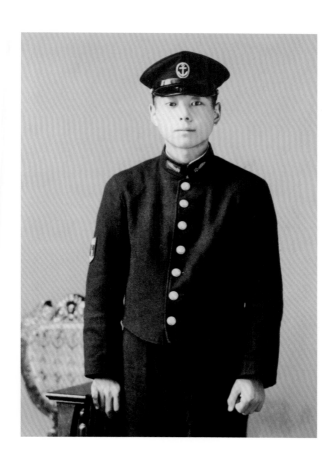

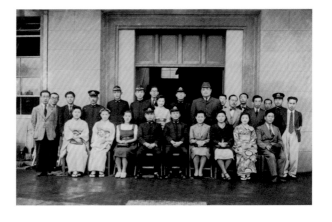

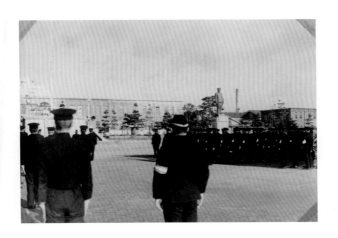

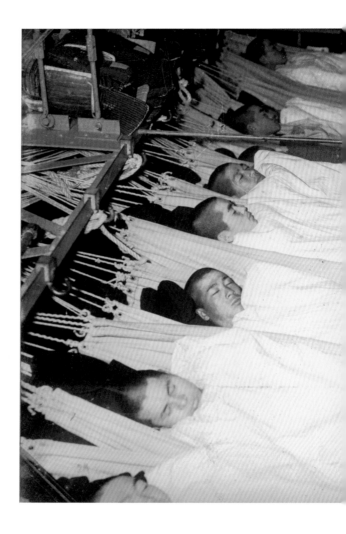

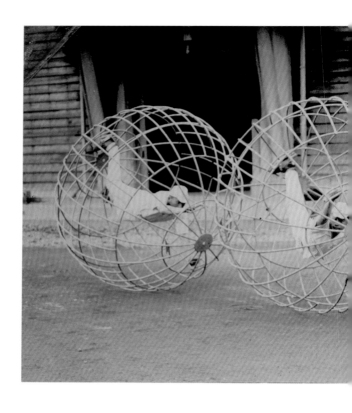

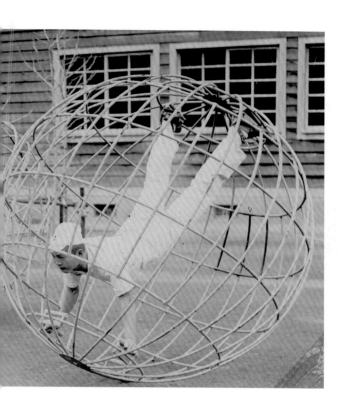

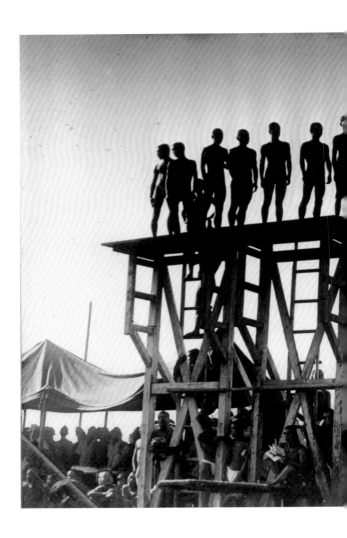

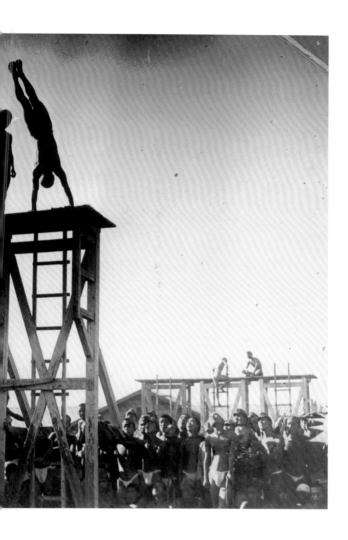

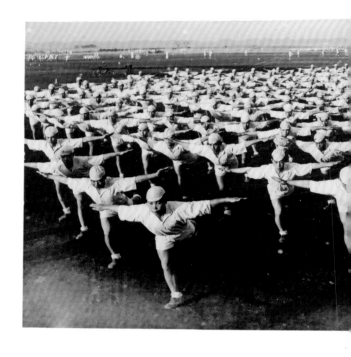

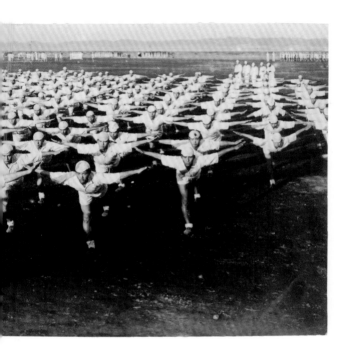

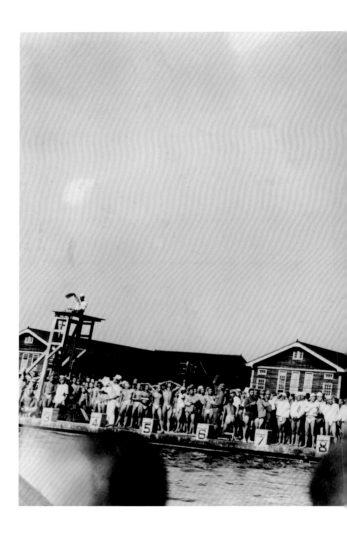

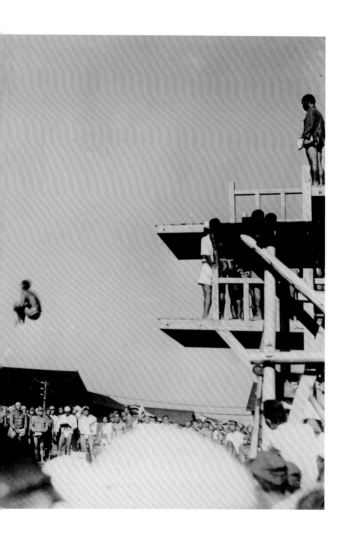

ACKNOWLEDGMENTS

I am grateful to George Tashiro for our discussions and for the loan of his kamikaze photo album, and to Wendy Hanamura for introducing us. I thank Iwao Peter Sano for sharing his recollections, and his son Stephen for setting up our conversation. Jimi Yamaichi was kind enough to reminisce about growing up in the San Jose area and about his time at the Tule Lake internment camp. At Tule Lake, National Park Service ranger Kenneth Doutt generously gave me and my daughter Lucy an off-season tour of the site of the camp. In Alameda, my friend Stephanie shared an afternoon reflecting with me on the presence of the past. In Honolulu, I appreciated talking to Thelma Kehaulani Kam. At Stanford and in Palo Alto, I owe thanks to the following people for helping me to think about this project: Timothy Cruzada, David Freyberg, Ala Ebtekar, Laura Jones, David Kennedy, Marci Kwon, Richard Meyer, G. Salim Mohammed, Steve Staiger, and Craig Vought. I owe special thanks to Nicholas Jenkins for reading an earlier draft and encouraging me to keep at it; to William Hurlbut and Stephen Crane for inviting me to share this material as a talk for the first time; and to Connie Wolf, whose encouragement gave me the confidence to pursue this idea in its earliest form. To my research assistant Anthony So, I am grateful for all his hard work, even if the final form of the book departs from the one I originally had in mind. And to my editor Lucas Zwirner, I say thanks for believing in this kind of writing.

Among the sources I have found most helpful are J. G. Ballard's *Empire of the Sun* (1984); Ruth Benedict's *The Chrysanthemum and the Sword: Patterns of Japanese Culture* (1946); Jeffrey F. Burton, Mary M. Farrell, Florence B. Lord, and Richard W. Lord's *Confinement and Ethnicity: An Overview of World War II Japanese American Relocation Sites* (1999); Gordon Chang's *Morning Glory, Evening Shadow: Yamato Ichihashi and His Internment Camp Writings, 1942–1945* (1997); Jirō Horikoshi's *Eagles of Mitsubishi: The Story of the Zero Fighter* (1981); Eri Hotta's *Japan 1941: Countdown to Infamy* (2013); James Jones's *From Here to Eternity* (1951); Akira Kurosawa's *Something Like an Autobiography* (1982); Evan Mawdsley's *December 1941: Twelve Days That Began a World War* (2011); Jim Rearden's *Koga's Zero: The Fighter that Changed World War II* (1995); Iwao Peter Sano's *One Thousand Days in Siberia: The Odyssey of a Japanese-American POW* (1997); and Nicholas Veronico's *Hidden Warbirds: The Epic Stories of Finding, Recovering and Rebuilding WWII's Lost Aircraft* (2013). I have also benefited from studying the Yamato Ichihashi Papers in Special Collections at the Stanford University Libraries.

ALEXANDER NEMEROV is department chair and the Carl and Marilynn Thoma Provostial Professor in the Arts and Humanities at Stanford University. Prior to joining Stanford, he was a professor of art history and American studies at Yale University. Among his books are *Acting in the Night: Macbeth and the Places of the Civil War*, *Wartime Kiss: Visions of the Moment in the 1940s*, *Silent Dialogues: Diane Arbus and Howard Nemerov*, and *Soulmaker: The Times of Lewis Hine*, a finalist for the 2016 Marfield Prize in arts writing.

"Ekphrasis" is traditionally defined as the literary representation of a work of visual art. One of the oldest forms of writing, its meaning originated in ancient Greece, where it referred to the practice and skill of describing people, objects, and experiences through vivid, highly detailed accounts. Today, ekphrasis is more openly interpreted as one art form, whether it be writing, visual art, music, or film, being used to define and describe another art form in order to bring to the audience the experiential and visceral impact of the subject.

By bringing back into print important but overlooked books—often pieces by established artists and authors—and by commissioning emerging writers, philosophers, and artists to write freely on visual culture, David Zwirner Books aims to encourage a richer conversation between the worlds of literary and visual art. With an emphasis on writing that isn't academic in the traditional sense, but compelling as prose, and more concerned with subject matter than historical reference, *ekphrasis* invites a broader and more varied audience to participate in discussions about the arts. Particularly now, as visual art becomes an increasingly important cultural touchstone, creating a series that encourages us to make meaning of what we see has become more compelling than ever. Books in the *ekphrasis* series remind us, with refreshing energy, why so many people have dedicated their lives to art.

OTHER TITLES IN THE *EKPHRASIS* SERIES

Ramblings of a Wannabe Painter
Paul Gauguin

Pissing Figures 1280–2014
Jean-Claude Lebensztejn

Degas and His Model
Alice Michel

Chardin and Rembrandt
Marcel Proust

Letters to a Young Painter
Rainer Maria Rilke

FORTHCOMING IN 2018

The Psychology of an Art Writer
Vernon Lee

Giotto and His Works in Padua
John Ruskin

Summoning Pearl Harbor
Alexander Nemerov

Published by
David Zwirner Books
529 West 20th Street, 2nd Floor
New York, New York 10011
+ 1 212 727 2070
davidzwirnerbooks.com

Editor: Lucas Zwirner
Copyeditor: Deirdre O'Dwyer
Project Assistant: Molly Stein
Proofreader: Deirdre O'Dwyer

Design: Michael Dyer / Remake
Production Manager: Jules Thomson
Printing: VeronaLibri, Verona

Typeface: Arnhem
Paper: Holmen Book Cream,
80 gsm; GardaMatt, 130 gsm

Publication © 2017
David Zwirner Books

Text © 2017 Alexander Nemerov

Distributed in the United States
and Canada by
ARTBOOK | D.A.P.
75 Broad Street, Suite 630
New York, New York 10004
artbook.com

Distributed outside the
United States and Canada by
Thames & Hudson, Ltd.
181A High Holborn
London WC1V 7QX
thamesandhudson.com

ISBN 978-1-941701-65-2
LCCN 2017949023

David Zwirner Books *ekphrasis*